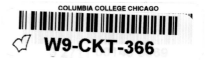
art on black

DATE DUE

GAYLORD			PRINTED IN U.S.A.

After Marx, Freud, Marcuse, and Jung,
Tune to Marley, Fanon, and d'bi.young.
This Jam-Can "jamette," orating patois,
Explicates "politricks"—like a good outlaw,
A rebel, a neo-Nanny-of-the-Maroons,
A Black-is-beautiful "womban" who can inflict wounds
In the name of "revolushun" and of revolt,
Seizing freedom to love and license to shout.
Bi, Lesbian, "Nubian," and mother of moon,
Miz Young don't cry. Miz Young don't croon.
She inherit the spirit and spunk of Miss Lou,
Rosie Douglas, The Last Poets, L.K.J., and Oku.
And so her Dub jams and jumps off the tongue:
Now, y'all yield your ears to d'bi.young.

—**George Elliott Clarke,**
Laureate, 2001 Governor-General's Award for Poetry

art on black

d'bi.young

women's press I toronto

art on black
d'bi.young

First published in 2006 by
Women's Press, an imprint of Canadian Scholars' Press Inc.
180 Bloor Street West, Suite 801
Toronto, Ontario
M5S 2V6

www.womenspress.ca

Canadian Scholars' Press/Women's Press gratefully acknowledges financial support for our publishing activities from the Ontario Arts Council, the Canada Council for the Arts, the Government of Canada through the Book Publishing Industry Development Program (BPIDP) and the Government of Ontario through the Ontario Book Publishing Tax Credit Program.

Library and Archives Canada Cataloguing in Publication

d'bi.young, 1977-
 Art on black / d'bi.young.

Poems.
ISBN 0-88961-458-X

 I. Title.

PS8607.B55A78 2005 C811'.6 C2005-905911-7

Cover and book design by Aldo Fierro
Cover and interior photos by Judy Singh
Body painting by Ras' Iriel

06 07 08 09 10 5 4 3 2 1

Printed and bound in Canada by Marquis Book Printing

Canada Council
for the Arts

Conseil des Arts
du Canada

Canadä

to my mother anita
to my brother johari
for my son moon anitafrika

...there is no
revolution
without passion
and spirit
and love
and pain
and sacrifice
and mistakes
and dancing
and sensitivity
and celebration
and funerals
and children
and sorrow
and burnout
and rebirth
and apologies
and confusion
and forgiveness
and vulnerability
and strength
and passion
there is no revolushun without pashun.

contents

I. dubbin revolushun

III. hybrid

artist's statement

i am a jamaican born/raised dub poet. it is an honour to be among the griots of the global afrikan village retelling our forgotten herstories. storytelling was taught to me by my mother. her mother before her and her mother before her were also storytellers. they weaved the divine struggles of everyday life in jamaica into quilted celebrations of worship, song, sorrow, and jubilee. i learnt very early that life—beyond poverty, violence, (self) hate, abuse, inequity, and degradation—is about gratitude, humility, love, healing, and struggle. storytelling as offering. it is through this ancient snake/womban/creatrix place that i channel. storytelling as possession. storytelling grounded in responsibility and accountability to the community/a reflection of me. ancestors/ase. orishas/ase. mother/all womben before and after/ase. freedom fighters/ase. life in balance is beautiful moon.

I. dubbin revolushun

di dub

dub is word. dub is sound. dub is powah. dub poetry is performance/ poetry/politrix/roots/reggae. dub emerged from the psyche/ life experience of conscious ghetto youth in jamaica and england in the late 1970s, early 1980s (such as oku onoura. mikey smith. anita stewart. mutabaruka. jean binta breeze. poets in unity. linton kwesi johnson. and many others). they demanded an art form that would represent and reflect the working class linguistically, socially, and politically. coming from the roots of reggae, dub fiercely challenges capitalism. imperialism. patriarchy. and other forms of oppression. while riding a wicked reggae beat. through this old/new form of poetry/music, an outgrowth of the afrikan griot tradition, jamaicans and people worldwide continue to identify with revolushunary art and struggle.

there are four main elements to dub:

one. language/originally story-told in the nation language of jamaica—a mix-up of west-afrikan languages/english/some spanish/some french, birthed from the colonial experience of the trans-atlantic slave trade—dub chants in the tongue of the under/working class. the form speaks to and for the people by breaking with british hierarchical linguistic rule and grammatically, syntactically, and stylistically represents the working-class experience.

two. musicality/at the time of the birth of dub poetry, reggae was urgently making a national and international name for herself. in jamaica, dance halls, street corners, the insides and outside of tenements were booming with the

4

inventive sound. through the storytelling culture of reggae music, dub poetry rode-di-riddim into the hearts of the people.

three. political content/dub insisted/insists on being a political form. based on the premise that people's personal realities are a result of political decisions, dub chants about grassroots working-class realities; emphasizing the cause-and-effect relationship between political action and social change. this analysis goes even further to analyze the socio-economic decisions that lead to poverty and degradation and offers solutions to change.

four. performance/dub is one of the many branches of mama afrika's griot tradishun. this ancient/present storytelling form demands musical, physical, and vocal creative embellishment of a story. live storytelling has the ability to transcend time and space and to magically transform a dub poet's tale into a story for the entire village; prioritizing the spiritual connection between the storyteller and the poeple. dub is primarily oral. this fact, however, does not restrict it to the stage.

I dub poet d'bi.young

I

sometimes She-wind shifts her course
swirls softly about my head making me remember
dub plates dancing on black vinyl
a slow rub-a-dub pounding the pressures
of a people transferred
dub/poetry birthing herself through a canal
of concrete jungle/chaos and/community
the griot in americas

II

dis/covering roots dawtah
a push 'gainst di parametah of a box-like strukchah. envisioning a more circular. form.
womb/and a dub ovah di version side a di 33 or di 45.
popular reggae vibez. when we siddung pon street cornah.
a watch di yout dem bout yah. a chant dung babylon. complex.
while a real/lize. fi tear dung yuh mus build up/and climb inward.
di cycle is a circle. weh mus continue.

III

I am a poet
whose heart in balance with the wind
stands still
I am
one
I am many
herstories
alone
one bridge whose links hang
worn
I am tomorrow's forgotten yesterday
a programmed amnesia
a dys/functional re/invention of the wheel
change is a hela/cycle
changing remaining the same

how will the scroll keepers grow
my son
how will you grow?

once dere was a man
(my first dub poem—1988)

once dere was a man
him had a plan
him had a plan but di plan nevah stand
di plan was dat to kill himself
suh him seh, mek mi jump off a one high shelf
him jump off a di shelf and bruk him foot
end up inna hospital haffi a read one book
him see one pretty lady
and fall in love wid har
but di only reason was dat she had a volvo car
him nevah waan dead again
and di day him fi leave di hospital
di nurse give him one injekshun
di injekshun did pyzen
and dat was di end of di man who had a plan

mama
(for mommy)

my mama used to say to me
cry cry baby moonshine darling
dry yuh tears and go to yuh bed
when you wake up in di morning everyting…

mama mi cyaan remembah what yuh used to say to me
cry cry baby
moonshine darling
dry yuh tears and go to yuh bed
when you wake up in di morning everyting…

mama i woke up dis morning and i still saw you
hurrying an scurrying
trying to mek it to work before six a clock
i watch as yuh hands move in confusion
yuh prepare breakfast lunch then dinner
time no longah on your side
yuh haffi mek a stride off to slave labour
mama what time did you wake up dis morning
to mek sure seh everyting was right
yuh get any sleep last night mama
what a guh happen in di morning
anyting a guh change

cry cry baby moonshine darling
dry yuh tears and go to yuh bed
when you wake up in di morning everyting…

mama di pickney dem
did mean to me today
dem tease mi again today
dem call mi a monkey again today
mama dem say dat mi ugly again today
mama dem say yuh nevah married to mi faada
dem call me an illegitimate dawtah
mama is it a crime to be a single moddah
was I really a gift from di creator
or was I a accident mama

cry cry baby moonshine darling
dry yuh tears and go to yuh bed
when you wake up in di morning everyting…

mama I saw you in di corner trying to hide dem tears
you fear
I know mama
dat yuh dawtah a guh breed
and yuh son turn thief before fifteen
yuh try to protect us from di ghetto life
but di ghetto life is worth living
if it makes you a stronger person
mama it made you stronger

when will there come a time
for di sun to shine on
your beautiful face
and put all these inequity workahs inna dem place
mama I don't want to be ashamed
and you should not be ashamed of being poor
cuz being poor is not a crime
yuh haffi know dat inna dis ya time
being poor is not a crime no
yuh haffi know dat inna dis ya time

I remembah
I remembah
I remembah what my mama used to say
my mama used to say to me
cry cry baby
moonshine darling
dry yuh tears and go to yuh bed
when you wake up in di morning
everyting is gonna be alright
so don't worry about a ting
cuz every likkle ting
is gonna be alright
I won't worry
i'm singing don't worry about a ting
don't you worry bout a ting cuz
every likkle ting is gonna be alright

mama I remembah
I believe you mama
I thank you mama
but most of all
I love you black mama
goodnight

cycles

mi wondah how great-gran di feel
when she had granny early
and how granny did feel
when she had mommy early
and how mommy did feel when she had me too early
one unprotected decision
and mi end up inna
di same shituashun
and now mi heart just a beat
and a pulse wid di heat
chrystal yuh a breed
anoddah pickney fi feed
dem kindah stress granny nuh need
mi nuh know weh mi did a do
fi mek dis happen
and granny warn mi
and still mi mek it happen
now mi end up all alone
inna dis shituashun
god nah guh tek mi inna heaven
no solushun
but to have an aborshun
mount zion say dat dis is an abominashun
but fi me dere is no oddah opshun

and granny feel disappointed
seh di cycle nevah end
all di resources and di cycle nevah end
pregnancy interrupted and di cycle nah end
mi wondah why mommy did chose fi have me instead

children of a lesser god...
(for likkle debbie)

yuh know mi nuh understand/why har uncle sam
insist fi hold up har hand when she a sleep
and if she open up har eye/and look inna him face
sam tell har fi shshsh/close yuh eye

don't be shy/don't mek no noise
cause mi nuh waan yuh moddah/fi wake inna di place
don't tell nobody what a gwaan/mi have a speshal love fi yuh
yuh moddah nah guh understand/keep dis between me and you

last week sam tek him time/and him climb pon top a har
den him open up him pants/and him hold down har hands
and all she feel is pain again and again

har granny used to say/dat in di olden day
dem used to put hot peppah in yuh punny
if yuh do it wid a man/and yuh is a likkle gyal
den you in di wrong/you mek it happen

granny nevah mention/like in most nashuns
likkle girls are children of lesser gods
we suffer girls and boys to come on to him
likkle girls and boys become toys to him

granny speaking from a place of experience
couldn't circumvent di event
dependent on di economic presence of uncle sam
raping sons and dawtahs one by one
and all she feel is pain again and again

and now it hurt between har leg/when she a walk
she haffi spread har leg apart/when she a walk
she haffi siddung pon har side/when she at school
cuz di benches feel too hard

di pickney dem at school laugh after har
dem point and jeer all day long
har best friend pam tell har fi look pon har skirt
when she turn it around/she get a big alert

she did a bleed and bleed/pon har uniform
red blood red blood pon har uniform
she bleed and bleed/pon har uniform
red blood red blood all day long

blood
is the colour of the rainbow/when brown girls consider suicide
is love not enough

uncle sam she nuh like when yuh touch har right dere
mama seh she shouldn't let nobody touch har right dere
uncle sam dis is wrong/please let go of har hand
uncle sam dis is wrong/please put on back yuh pants

tonight she a guh sleep wid a knife
pam tell har uncle sam at night should only touch his wife
she tell him she nuh want him speshal love
but him still insist fi tek har from above

tonight uncle sam tek him time
him climb pon top a har/she sink di knife into him spine
him nevah hold har hands/him nevah tek off him pants
and all him feel is pain again and again

ain't i a oomaan

teachah seh: welcome class to feminism 101
we a guh talk bout gloria steinem/betty friedan
di liberation of di white middle-class oomaan
from oppreshun in society
di solushun of which is to go out dere
into di work force and work

darkness/di absence of light skin
widout white skin
darkness/I have been force-working
since I was brought here

teachah seh: oomaan get di vote inna 1918
mi nuh really understand weh she mean
when you say oomaan/be more specific
if me remembah correct/1918 mi nevah did a vote yet

georgy, you best go gets cleaning ups now
yuh hear, aunt jemima gonna make you some real nice pancakes

cum mek we look pon dis ya shituashun
dis feminism 101 where we elaborate pon betty friedan
gloria steinem
cannot have room for I
it forces di exclushun of di black oomaan
black black black bush oomaan

and ahdri zhina said step into my head
cum on and step step step into my head
black bush womban
step into my head where fear and loathing
stalk single stands of my kinky hair
beauty looks warp as you exotify me
a sexualized/demonized

but we both agree
dat mammy raise black and white pickney
dat tanty raise black and white pickney
dat auntie raise black and white pickney
yuh nanny raise black and white pickney

mi lips a likkle ticker/mi nose a likkle broader
mi ass a likkle rounder/mi skin a likkle darker
makes me an outsidah

and darkness is di embrace of di absence of light
darkness is black womb/weh we all come from
black oomaan
di beginning a feminism
ain't I a oomaan sojourner
truth come find me

revolushun I
(inspired by lkj/for dave austin)

bwoy mi friend
it look like revolushun come to an end
di left is di right's right-hand man
and so tonight i will curl up in front di tube
and watch seinfeld, ally mcbeal, and friends
so dat i could be part of society
my priority to sport new nike
cuz mi friend
revolushun
come to an end

but wait
what kindah helpless hopeless state
dem have we di people inna
saying we have no power to effect change
but dat we do have di dollar
fi buy coca-cola
mcdonald
levi
pepsi
tommy hilfiger
nautica
ralph lauren
and dkn

why?
do they try to distract we
from di harsh reality of living inna dis ya society
we both know who is truly financially backing capitalism
breddahs and sistahs feeling naked
widout dem tables of labels

mi friend
revolushun come to an end
di left is di right's right-hand man
and tonight i will lie down
in front the tube
and watch geraldo
rikki lake
and jerry springer
so i could feel a part of society
my priority to sport my new nike
cuz mi friend
revolushun
come to an end

but how revolushun fi dun
when you walk around
downtown
yuh nuh see di urban slum
beside di soho
a slow mo
beg some change
passers-by pass him by
keep yuh eye straight ahead

how revolushun fi dun
when beside eaton centre
disney store
a sex trade worker
so called whore
is a oomaan of colour
is a single moddah
jus on di cornah
jus begging a dollar
jus trying trying
trying to mek a living

how revolushun fi dun
when inna dis ya state
fi we drop out rate
way too high fi mention
and unda unda tension
we bop our heads to bmg sony universal
"gangsta rap"
bap bap
kill each oddah off
bap bap
kill each oddah off

mi friend
revolushun come to an end
di left is di right's right hand man
and tonight
I will curl up

lie down
in front di tube
and watch
all my children
di bold and di beautiful
di young and di restless

but I am young and restless
so revolushun cyaan dun
not yet

our fore-moddah and faada
committed to we struggle
dem nevah lie down
curl up
get too comfortable
anywhere

assata shakur
amilcar cabral
frantz fanon
winnie mandela
che guevara
queen nanny
steve biko
fidel castro
sojourner truth
stokely carmichael
angela davis
and dis ya list goes on

I want to watch dem
I want to breathe dem
I want to feel them
cuz they are my revolushunary friends

revolushun cyaan dun
you/me/you/you
and even you
feel it beating
bleeding
boiling
blood pumping
inna we veins

revolushun cyaan dun
cuz we
di people
are the revolushun

untitled or butterfly

(for roger.boogieman.derrick brown.patricia smith.lyn.reggie gibson.
jeff.dj renegade.saul williams.jessica care-moore.steve canon.alexis.
dayna.sara.johnny.nadine.peter.auntie cherry.janel.grandma.brandon.
russel.the nuyorican poet's café.cbgb's.and jason)

mi waan fi do some amerikkkan dreaming
pretend mi living in di perfect system
where class and colour have no meaning
but when mi guh to bed last night
mi get a likkle fright
mi see a baby die
and mi hear a soldier cry
but all is fair inna love and war
een star?

butterfly wings smear magic dust on my shoulders
I levitate
and wait
to come crashing
crushing the beings underneath my feet

cum mek we do some amerikkkan dreaming
pretend dis prison industrial system
is a figment of imagination
pretend di move 9 did commit a heinous crime

advocating equal rights to relieve di people's plight
pretend political prisoners and prisoners of war
have a jolly good time in solitary confine-
ment, dem need time fi think
but all is fair inna love and war
een star?

butterfly wings smear magic dust on my eyes
and I speak of a time when the sublime
was unnecessary
and harry met sally
and there was no place for me
and blackbirds leaped
and there was no place for me
and tentacles combed through my nappy hair
and there was no place for me
and robes rode my back
and there was no place for me
and clones droned by
and there was no place for me
and humans cry

mi waan fi do some amerikkkan dreaming
pretend mi living in di perfect system
where class and colour have no meaning
but when mi guh to bed last night
mi get a likkle fright
mi see a baby die
and mi hear a soldier cry

move 9 did commit a heinous crime
advocating equal rights to relieve di people's plight
confinement, dem need time fi think

mi see a baby die
mi hear a soldier cry
mi hear a baby cry
mi see a soldier die
mi hear a baby die
den mi see a soldier cry
but all is fair inna love and war
een star?

if I could
I would kiss you
feed you food from my mouth
stop you from aching
share a smile - wait by the roadside for a while
and humans cry

why do frogs sing
and secrets lie hidden below beds
why do clouds shimmer
and dead
babies hold infinite wisdom

butterfly wings smear magic dust on my
unimagined amerikkkan dreaming,
and I sleep

pretend mi living in di perfect system
and still humans cry
where class and colour have no meaning
cause all is fair inna love and war
and still humans cry class and colour have no meaning
all is fair inna love and war
and still humans cry all is fair
and still humans cry fear
and still fear cries war
still in war cry love
and still
dis ya human love a cry
and dead
babies hold infinite wisdom

I fell asleep last night
my eyes bled
I need time to think
een star?

johnny fi horrett

see mi deh
sitting inna café
pon a tuesday
mi turn to di waiter and mi seh
"waiter come yah
and just serve mi a beer waiter
light mi a cigarette waiter
mek mi sniff dis ya poison air
cuz mi dear
mi nuh waan fi be here
no more"

di waiter stand up beside mi
couldn't understand
weh a gwaan inside mi
but mi decide fi tell him mi story
anyways
yuh see
mi friend johnny
johnny dead
pump wid lead
inna di head head
by di police
fi a sell weed

I knew it was coming
day in day out johnny hustling
to mek a living
to feed di sistren himself
and di pickney

but waiter
dis ya mash up shitstem
we thrive in
mi poor friend johnny went jiving
two shots
johnny was bleeding
and bleeding and bleeding
right in front di café
I was sitting in
last week monday evening
johnny was a good man

di waiter just stood there
"mad woman what are you doing in here
I have no time to listen to you
I have my own shit to do"

so mi seh
"den waiter how 'bout yuh
serve mi anoddah beer waiter
light me anoddah cigarette waiter
mek mi sniff dis ya poison air
cuz mi dear mi nuh waan to be here

cuz mi dear yuh waan to be here
cuz mi dear we nuh waan to be here
we nuh waan to be here
we nuh waan to be here
no more"

johnny was a good man

a poem for rosie douglas

lawd anoddah library
burn down
anoddah one

I watch you
go
as tomorrow mourns
dis history claims

before I cried
I smiled
remind me
of your cross
into
freedom land

come mek we celebrate
rosie gawn

yemojah moon phoenix

(for olokun-mwedzi)

yemojah
yemojah
moon phoenix
a suh yuh name
suh wi chant it
suh yuh be it
yemojah
moon
phoenix

jazz

I love you debbie
no you're lying to me
I love you debbie
no you're lying to me
how could you love me and treat me this way
old habits die hard at the end of the day

I woke up this morning
I saw you staring at me
in the mirror
and you didn't greet me
didn't say hi
tell me why
you turned your head and started to cry
debbie why can't you look me in the eye
you don't love me
you don't love me

tell me debbie
what have you been told
what have they sold you debbie
what have you been told
oh don't believe them debbie
don't believe what they say

old habits die hard at the end of the day
old habits die hard at the end of the day

I saw you debbie chopping some cane
I saw that white man be a savage
as you screamed in vain
I saw your children sold in bondage
for a candle stick
you're not a mother you're a breeder
and you cracked under dat whip

tell me debbie
what have you been told
what have they sold you debbie
what have you been told
oh don't believe them debbie
don't believe what they say

old habits die hard at the end of the day
old habits die hard yes at the end of the day

I saw you studying until it was 6am
I saw you working until it was 10am
I saw you going to school until 4pm
I saw you playing black nanny till 10pm
I saw you cooking-cleaning-washing-feeding
washing-cleaning-feeding-cooking
cleaning-feeding-cooking-washing

feeding
cooking
washing
cleaning
cleaning
cleaning
cleaning
taking care of that man
who don't give a damn about your calloused hands
who don't give a damn about your aching back
who don't give a damn about your tired heart
who don't give a damn about your breaking feet

five hundred years
five hundred years

tell me debbie
what have you been told
what have they sold you debbie
what have you been told
oh don't believe them debbie
don't believe what they say

old habits die hard at the end of the day
old habits die hard yes at the end the day

whenever I go by
the friendly corner store
I can't deny the urge

of wanting magazines galore
white images of beauty
(straight nose)
are haunting taunting me
(long hair)
white images of beauty
(no lips)
like sailing shipwrecked off at sea
white images of beauty
I know they cannot set me free

these nurtured insecurities
as they commodify me
robes are riding on my back
as they build this economy
dark and lovely hair straightner
ambi skin fader
wax hair remover
and don't forget max factor
to cover your face
cuz you come from an ugly race
why don't you cover your face
cuz you come from an ugly race

and like a festering sore
keep wanting more
and more
and more
they just help to cultivate

my internal self-hate
vultures flying in the sky
waiting to prey on I and I
these vultures flying the sky
waiting to prey on I and I
waiting to prey on I and I
waiting to prey on I and I

you don't love me
five hundred years

I woke up this morning
I saw me staring at me
in the mirror
and I didn't greet me
didn't say hi
tell me why
I turned my head and started to cry
debbie why can't I look me in the eye
I don't love me
I don't love me

tell me debbie what have I been sold
what have they told me debbie
what have I been sold
oh don't believe them debbie
they are lying debbie
don't believe them debbie
don't believe what they say

old habits die hard at the end of the day
old habits die hard at the end of the day

these old habits must die
at the end of the day

revolushun III

i'm screaming revolushun in the name of the people
until I stop to ask my people
what does it take to make a revolushun
is there space for hate in a revolushun
can i be consumed by hate and make a revolushun

sisters and brothers we need to unite (raised fist)
but I hate those fucking homo bastards (hitler salute)
brothers and sisters we need to stand up and fight (raised fist)
but I hate those lesbian bitches (hitler salute)
sisters and brothers we need to speak the right (raised fist)
all those queer and transvestites fire bun dem (hitler salute)

is there space for hate in a revolushun
can I be consumed by hate and make a revolushun

hot damn
when I catch me a nigger
I like to string him by his little nigger neck
you know how dem niggers be hollering
but den you hear that pop
when the nigger neck snaps
den that fat nigger tongue comes hanging out
I like to see that nigger tongue hanging

and those big fucking nigger eyes
popping out all scared
I love to see me a scared nigger
dat's how you know
you done got another one a
dem nigger bastards
we done got another slave nigger bastard

from days not so old
they sold and hung our souls

centuries fair barter
erased
new economic structure
racialization of skin colour
demonization of afrikan culture
slaughter
my people
do we remember

those days of old
they sold and hung our souls

now we are
hunting
beating
beseeching
begging
and yearning

for the hanging
the lynching
the murdering
the fire burning
of a sistren
or brethren
thirsty for blood
blood sucking
filled with hate
hate preaching

do we remember

we been through persecution
and now we persecute
missa youth what-a-gwaan
come quick and gimme likkle truth
mi nuh know how fi understand di shituashun
everyday wi get up and preach revolushun
to di nation

how mi fi hate mi breddah man because him love anoddah man
how mi fi hate mi sistah gyal because she love anoddah gyal
so mi fi hate myself cause mi love oomaan and man
mi fi hate myself cause mi love man and oomaan

wi been through persecution and now wi persecute
missa youth what-a-gwaan
come quick and gimme likkle truth

did we work for the right
to perpetuate hate
our slave daddies
taught us well
how to hate

(hitler salute)
hatehatehatehatehatehatehate
I hate those fucking homo bastards
hatehatehatehatehatehatehate
I hate those fucking nigger bitches
hatehatehatehatehatehatehate
I hate those queer motherfuckers
fire bun dem to all black niggers
fucking slaves
judgement for all batty man and sodomite
you're going straight to hell
hatehatehatehatehatehatehate
I hate you and you and you and you and you and you
and you know what if I was white I would fucking hate black people too
as a matter of fact I do
all you fucking dyke
queer
gay motherfuckers

what does it take to make a revolushun
is there space for hate in a revolushun

I cannot scream revolushun in the name of the people
until I stop to ask my people
can I be consumed by hate and make a revolushun

there is no room for hate in my revolushun

kiss for natasha

(for miss lou)

last night, inna di middle a di light
miss merl
mi kiss a black girl
i could see har
and she could see me bright

now mi know it taboo fi true
but mi coudn't keep dis ya infamashun to miself
mi first kiss wid a girl
mi haffi share it wid somebody else
keeping it in would surely be a sin

har lip dem curl in toward mi
nevah know what lick mi
and all mi try
mi couldn't close mi eye
cuz dis was not like when yuh kiss a bwoy
and yuh lock yuh eye dem tight tight tight
and pretend you is a princess
and him is a knight
no it wasn't like dat dis time
me wanted to see
when har lip dem touch mine

feel we mouth juice
intertwine
and touch di tip of har tongue
caress har teeth
caress har gum
and taste dis womban sweet—
a dan a man

mi kiss a black girl
last night
inna di middle a di light
miss merl
i could see har
and she could see me bright

and mi see peenie wallie
twinkling star
feel like mi mouth de pon glass
no fire
and wid each suck she suck een
mi lip dem get wetta
and wetta
dan evah before
a yearn fi more and more and more

and dem mi realize
stop dead inna mi trak
so mi nearly ketch up
heart attack

miss merl
is a black girl
mi did a kiss
wid two breasts
a round rump
broad hips and two dark lips
like mine
har skin brown and shine
like mine
har leg dem strong and thick
like mine
and wid di absence of dat prick
di powah play was a trick
cuz dere was no powah play

and in some small
part a mi mine
mi wish mi could freeze
dat feeling in time
and tek it out when mi feel
dispossess and oppress

cause inna
dis ya powah structcha
di black oomaan deh
well, she deh
a di bottom a di laddah

and suh when mi kiss dat black girl
inna di middle a di light
miss merl
and I could see har
and she could see me bright

a di first time mi feel sexuality
wid some real equality

I. dubbin revolushun

dis ya tongue a twist

tongue tied
twisted around dis macka fence
of language
of life

the orisha letters

(inspired by akin/for kaie)

moja

dear ogun
was it olodumare who
wrote our distance on the clouds
this morning the sun
flirted with me
in your absence
though
her embrace was merely routine
not a spontaneous caress
wind stroked my ear
whispered your name
all day
I worked in the fields
noon-day sweat damped my lower lip
and
I inhaled you across a thousand
and one nights
ogun

can destiny
carved
on
vanishing sky
be rewritten

mbili

dear yemoja
do not be anxious
our tribulation is
short-lived
fate
an unusual friend of mine
promised our eventual
hereafter
I believe him
you visited the zambezi
high sun river bathing
on a saturday morn
you didn't see
me
when you went behind the macka tree
I watched
you removed your
lappa

stroked black hairs crowning breasts
and belly button
river waata lay them flat
I watched
fingers fall lazily against your dark
grass patch
and you began to braid
ha ha ha ha. yemoja
if only I could have touched you
then
my tongue
your personal bush comb
to tidy pearl black nipples
zambezi river deep belly button
thick bush at centre
yemoja I thought you
in a dream

tatu

dear ogun
I had a dream
you kissed me with
chalk on your lips
my tongue searched
powder thick hoping
to find home

familiar
you covered white across
my face into and
under my eyes. they burnt
you smiled
I dreamt
you tasted disgust and hate
denied me holding you
three times over
you turned your back
smiled as my eyes
burnt. I could not feel you
ogun
I dreamt
you turned your back
you turned your back
you turned
you're b(l)ack ogun
my eyes
still burn from chalk

nne

dear yemoja
she came to me last night
(her)
lips fell upon my brow

(like)
a thousand lashes
I did not refuse
yemoja and tasted the absence of soft mud
skin
I could not refuse
yemoja
I longed to be absorbed
undefined inna
gentle
dangerous breeze
a caress
I needed her to remind me
of you. I closed my lids and
beckoned you here
you did not come. chalk thighs into charcoal thoughts
charcoal thoughts into chalk thighs
last night I mistook chains
for space
I
look at myself
I no longer see your eyes
I am writing to tell you
nothing
but to shape touch from
tears. I am sorry
yemoja

tano

dear ogun
some wounds run
deep dark wounds
some wounds run
red blood wounds
some wounds run
no amount of loving
caressing pleading
begging
can heal these wounds
some wounds run deep
inna di dip crack a mi back
scathing pon dry cake-up bone
slithering through puss and grime
festering spots
some wounds run b(l)ack
some wounds run b(l)ack

sita

dear ogun
your thoughts
have not graced
time
has abandoned
me. alas

olodumare wrote
our destiny
not on clouds
but in stone
an irrevocable
distance. I have
waited
beyond perpetual
sunrises
(and sunsets)
to depart
ofe land
in the distant
past
had hoped you
would join
me
some wounds run black
ogun
with time
they heal
I thought
I saw you
on yester-night's
midnight moon

saba

dear yemoja

yemoja

yemoja?

yemoja!

destinations

time

limits

fear

I am in no hurry

words for the wall

(for david and joseph neudorpher)

those who have not forgiven me
let them understand
I walk in my mistake

those who have forgiven
bear fruits plenty

those I am unable to forgive
show me wisdom

poem for my mother before I go

mom bent down
on the phone
with my red-headed friend
"how's your father
how's your mother
coping with you leaving?"
she undid my
shoelaces
nights before my departure

dear mrs. cohen

I thought to have children
nature's longevity
with each experience
my wisdom widens
your son teaches
me how to love
thank you

raphael knows passion
for sweet seconds
I have seen your eyes

dear mr. cohen

tomorrow
I will be
old
wisdom and trust
lessons my grand-mere taught me
I cannot hear until these ears have aged
there are things
you know
raphael and I do not
I welcome knowledge

3 for raphael

I

I believed before
possibility
seeing past
wrinkles
I do not need
to understand
to know

II

time
is
a
still
missing
you

III

and when you find
love
let me weep
silently I will know
sadness
and joy
like tomorrow

herstory

it is difficult
to understand
fear

playing
"a brown girl
in di ring"
in my
belly

over herstory
and centuries
young
trees

ghanaian red roses
(for pablo)
hakema
I am thinking you
wrapped in cloud's night
piercing poetry with rhythmic trilogies
of hip-hop and hyp-nosis
loving you loving music loving me
I am thinking you smiling from century
to tomorrow with a reflection
of yourself that you recognize
to be ancient and wise and present perfect
hakema I am thinking you
wrapped in me wrapped in belief and faith
wrapped in three
I want to divide myself
times your love
equals a future of memories and today
hakema I am thinking you
enveloped by everything you need
laid at your feet

sent on the wings of a messenger
in love with your essence
your presence for being
you are alive
because life decided to bless herself
a dark emerald

hakema
know this
I love you like the safe blackness of night
fierceness of day
yellow truth of sunflowers
mystic blues of the ocean
I love you like dreams
caressing your aching bones
with morning dew
from ghanaian
red roses
hakema

small dangers and rivers that bleed
(for adam)
I take you in. a black breath
ancient sacred. we are so overdue
I hold you. in a space we are both familiar
a mirror reflection. with future expectation
I breathe. hold
so you feel the pulse of my blood. bleeding an unquenchable wound

in the fester of today. I touch you
like a black womban
knowing. too much.
how soothing the ocean bed is
our ancestors
whisper coldly. from there. other times
blood and fire. the taste of not forgetting
when will you let me hold you
we are so overdue. strong and discovering
I send you an ancient embrace
let her kiss your lips with the sweet bitter taste of struggle
I am too far to do it myself

the fat womban

folds
undulating
hills and valleys
riding
her riddim of flesh
I saw her today
musk clouded and firm
a temple
she stole
nature's sacred form
inna cyclical balance
your mounds in
I want to be comforted

nature is a womban's pussy

when I say I want to be inside you
I do not remember the nine months
sojourn
in my mother
your face
my tongue and teeth
on your breast
I do not remember being breast-fed
this comfort does not remind me of childhood
it feels as safe

when god was a womban

I have tried
masked in adoration
I have tried

I do not enjoy
your
haunting stare
lodged in me
like the iron bar
in
frida kahlo

I do not enjoy
your menacing linger

womban in the rock

I

wanted

peace I asked

for peace and

movement and the

sun

with

water I wanted stillness

and rhythm

bound in

motion anonymity

movement stillness and

mountain

I wanted time

and sun

to return to stillness

bare breasted

I wanted feet

to walk

still

a head to turn

I wanted to run

and be quiet

I wanted peace

the womban in the rock is there because she believes
she is happy to be still and alive

womban a heavy load

she carries with her
a heaviness
not known to me
she
is
sad
before
a beginning

self-serving malachites

what makes it poetic
romance
the un reality of truth
thin line between gift and arrogance
or is it pity
pathos for the hungry
self-serving malachites
giving "starving children in ethiopia" bread!

flowers die too

you have me remain
and wither
you admire me everyday

66

you smile
and continue to water
these shrivelled roots

for karen
in the sun until our bodies beg
you
three or four times darker
inside my palm
me
a deeper shade black

I remember I avoided her
(on that island
too long away to still know her language)
monkey of afrika
I resembled

I remember at whatever cost
wore tall sleeve shirts
long pants
walked around with an umbrella
stayed in for lunch

now
blackness walk through me
the sun
drippin' heat
is lit

locusts

this relationship is plagued
with me
with you
with me

self-esteem

I miss work
I am unworthy
without it

what they do

smoking causes cancer
danger: smoking is hazardous to you health

this summer
I ate
cigarettes
more than
I ate
you

enka

what happens
when welcome
wanes
do I whimper like a
dog
around my master's house
hang my head
and tail
beg to be
fed

western medicine

you bought me
pills
you felt
entitled
to make me sick

absence

without poetry
there
is
no soul

nothing
more insulting
and sad
the
unpoetic man

romance

sometimes
your romance
a fault
I can
not believe

when madness comes

(for jason last)
madness came
held my head and whispered
"this insanity reminds me of humanity"
half insane
I responded
"tell tomorrow I am a tear in debt
streaking through today"

womban and mad

haiku for alex

she was he thought some-
one's hidden half hiding the
underside of soul

for mumia

u.s.

us

united states

uncle sam

un stable

not firm or

firmly fixed

un steady

liable to change or fluctuate

quickly

us

uncle sam

u.s.

floods and hurricanes

tornadoes and earthquakes

an unstable weather pattern marked

by emotional instability

uncle sam

united states

us unsteadfast

irregular
in movement
an unstable
heartbeat

oya gate keeper
to the cemetery
blood and fire
brimstone and tundah
pon we

death
there is no
where
to be
but death

haiku on death
my becoming death
is a joyous occasion
like blindness sees stars

a love poem

no money
no privilege
no money
no space
no money
his racist parents
no money
her hate

blasphemy

middle of nature
what does it mean
honking cars
toxic perfumes
buildings graze
blasphemy
and bulldozers
trucks
four wheel drives
pesticides that kill
not only weeds
and (I cannot remember
are they not the middle of nature
ours
so far removed from life

so far above life
our nature is sadistic
he is pessimistic
and fatalistic

I am no longer in the middle of him
giving head
having him cum
all over my psyche

holy mary

no I do not see passivity
caged inna womb
and welcoming bondage
today I flow blood divine
my peace
not in the trinity
nails are all invisible
no/all in my head
no/all in my womb
a mirror
a sword
a shield
reflection
pierce me like truth

solidarity

to disclaim
is to
not
believe
in
revolushun

fuck disclaimers
and
people
who
do
them

a creation story for saul williams

I scrape white into my fingernails
scratch
scab thin sky
exposing the moon

clouds bleed blues
moon breathes mood
sun burns light in my retina
sun wants me to meet son again for the first time

my sweet jealous ungrateful child. you can never rule the night

I touch her crescent eye clothed in black
with faithful confirmation
she smiles me a cycle of punctured familiarity
I remember
hereafter

oh that day I drag my tears against earth's zinc
fences
and feel a thousand futures where her defences are…

black and moon sponged me
with wrapped silhouettes
wading in moon's night

I touched the moon
she smiled me a kiss
seeded me
with black
we conspired consecration
before time
gave passing to the son

black
moon
and
I gave birth to the sun

this may be the last
time
I see you su/on
forgive me for holding you
close

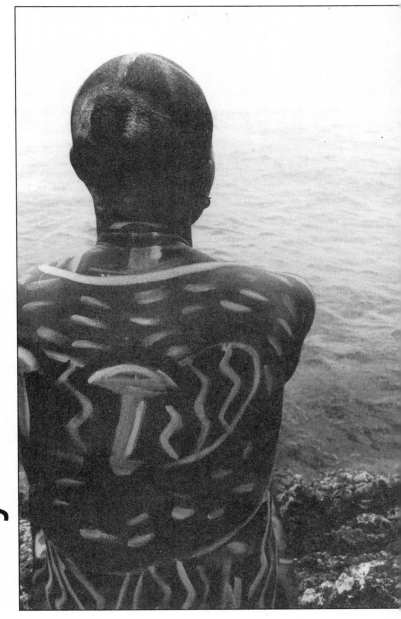

III. hybrid

letter to tchaiko

tchaiko negotiating this hybridism is a challenge. I have no place to place these contrived memories of mine. I did not experience that side of jamaica. but I know it exists. womben who are amazons having to reinvent themselves. like the snake. the goddess. so they can stay on top of the game. as opposed to underneath it. as dis shitstem would have it. we need to return and tell of the truths. weaved into lies. then sold to us.

I was born and raised in maxfield avenue kingston 13. never left till I was 15. so it's kindah fresh in my mind. but not fresh enough. I remember walking barefooted. cuz I loved the feel of concrete jungle. I knew even then that that shit was making me tough. like I would need to be. whether I stayed in jamaica or not. I remember fighting through my working class status at campion college. the first half of which I spent twisting my tongue into the queen's english. the latter half I spent showing off my nation language because I was *authentic ghetto*. moved to canada and got some legitimization for my outspoken wombanism. didn't need to shake the habit of liking the ways womben's breath felt under my breasts.

moving from jamaica liberated and stifled me in so many ways. I moved to toronto in 1993 and you know how that shit goes. first lost. then found. then you hang out somewhere in between. a hybrid. dub poetry is my link. had it taught to me in that old griot-tradishun way. by my mother. anita stewart. now here I am, trying to reclaim the wombanism in the art. so I rhyme about bleeding. and androgyny. and di maroons. and womben's rituals. and struggle. and death. and liberation. and love. I rhyme about love.

I came to cuba a year ago on a family myth that my grandfather was cuban. and
also needing to be in jamaica but not knowing how. I came to cuba instead.
with a freshly shaved head. a huge smile. a loud mouth. but no words to speak
spanish. oh and I came with a little money. had the idea to create music here. the
language barrier worked for me. playing with an all-male band singing BLOOD.

singing that to an all male band. it helps if the band only has an *idea* of what
you are talking about. the language barrier gave me enough time to earn
people's love and trust. time for them to release their defences to this womban
defending life. I left five months later with a demo cd. on the promise that I
would return and pay people properly for a full length professional album. two
weeks before I left. I fell in love. with hakema.

I mean what do I know about that love business … but fi real. all the tentative
energy around this kindah love. all the economic fucked-up-ness of being
foreigner and friend.

my favourite thing to say to people here was/is "I am jamaican. I was born and
raised in di ghetto. trust me I know." that does not account for the fact that I am
also canadian. a canadian government recognized and supported artist. I go and
come as I please. I have a home in canada. I no longer occupy the same economic
class/space I did when I was growing up in maxfield avenue. what a flip of di script.

each time I come to cuba i am faced with this reality. in canada i am a queer
working class artist. who lives on the margins by choice. when I come here. I am
north american. who doesn't speak very good spanish and who flies like I am taking
a walk down the street. the average cuban does not have that kind of access to
air travel. always negotiating this hybridism and knowing that the choices I make
around who I love and how I love them are always political cuz everything is political

.silence breeds...

how many rivers do we have to cross over to the other side majority rules oprah
says can't we all just get-a-one bright day I want you to mention darkness not
horror wickedness ugly duckling they used to call me but now I am pretty
benetton gap say so enough to make their clothes for less than a dollar I
sport them everyone applauds how good I look compliment me on my fine
sweatshop gear don't think just wear them thin my hips have been getting
and my thighs and ass she tells me to thank god I don't have that big black
girl's ass she does she hates it I wish it was ok to be rounder prouder nowadays
everything is marketable like those shirts with the chinese writing dumb
westerners wear them with no idea of what they say I wanted one tonight I
shut my eyes tightly released the world looked the same insane going to school
dissatisfied I have tolerance for sad people and less tolerance for happy people
they're fake beginning to care less and less about what you think I dream
about bell hooks at night audre lorde in flight it's alright recognizing beauty
in imperfection mama raised me right not straight don't want to be no longer
afraid of your insecurities you smile it's more dangerous to laugh cry for real
you've never been traumatized you're a liar it's easier to be on the other side
of the fence I'm on it don't need to be wiser than you like it from my point of
view I live free.

brown skin lady

I

"come buy some ackee from mi nuh nice girl"
"ay foreignah, mi waan talk to yuh likkle bit you know"
"dark skin lady, a selling some yam and banana over here, yuh want any"
"rasta pickney, ay naturalist, come here nuh man"
"afrikan princess blessed"

when I walked in jamaica I floated in on water
washed up against the heat and nostalgia
I embraced my soul
allowed her to kiss my face
and sweat canada out of my pores
out of my armpits
above my tits
below my lips
out of my punany
an island exorcism

"come buy some ackee from mi nuh nice girl"
they hollered
they psssted
they call to mi
they touched my hands and sometimes refused to let go

I wanted them to
hold on
tightly
jamaica had not forgotten what I felt like
for that I humbled myself

II

"so who dead now"
"well johnny dead
harry dead
clive dead
and
barry dead"
"police kill di whole a dem"
"no only 2
gunman kill di oddah 2"

my jamaica had not changed

"dem kill horret cuz him wouldn't tell dem where one a di twin dem live"

horrett, my man when I was way too young to have one

"dem tek juney frock from off di clothes line
wrap it round him head
so nobody wouldah hear
and shot him dead
two time
rain di fall di morning"

horrett
my man when i was too young to have one

i want to crawl into you jamaica
protect me from yourself

III

purple skirt
white blouse
purple tie
I was a campionite
campion college
intellectually the best of the best
we were supposed to be
although everyone knew money had mystical powers
I almost fit
my
thick-ghetto-jamaican-accent

I spoke like this at home

"nuh becuz mi poor mean mi nuh belong 'ere
mi belong 'ere jus as much as you do"

the same sentence
the campion way
the british jamaican way
the best of the best way

"not because i am poor means i do not belong here
I belong here just as much you do"

so I told myself repeatedly while I cried to sleep at night
bloody battled by day
for four fucking years

when I spoke like this at school
I fit
almost
my ghetto-thick-jamaican-accent
refusing to lie
still

I didn't visit campion on my trip
I had planned to
instead I drove by eating
a mango

IV

and the strangest thing is I think she liked me too

oh she rides the finest horse
that i've ever known
standing six feet one or two
with eyes wide and brown

you know one of those
never-to-be-done-or-felt-kindah-things

at 13 I had a crush on my six-years-older-than-me-cousin's
girlfriend
who was five years older than I was
tiesha
when I went back she was there
had two kids
a boy and a girl for my cousin ken
hardy and shauna were there names
beautiful children

she looked the same
smelt the same
when I hugged her felt the same
and those eyes

oh she rides the finest horse
that i've ever known
standing six feet one or two
with eyes wide and brown

I promised tiesha I would write to her
strangest thing is at 13 I thought she liked me too

V

I got none in jamaica
I had planned to
with a 12 pack of trojans in my hand luggage

by the third day I had given four to my 19-year-old cousin
and eight to his 13-year-old sister
she's my favourite
a miniature debbie

Vl

I did think of you canada
at which time I felt nauseous—
guilt for wasting my time
on such nonsense

Vll

and you my ambered friend
I thought you too
if you were there where would I put you
I would wait till black came
spread you like sunshine
while jamaica slept
I would kiss you
share a smile
in the dark
in the deep
in the night
in the heat

Vlll

now they are married
I know a sin
mi nuh like when yuh touch mi right dere
mama seh I shouldn't let nobody touch mi right dere
she now married to him
who loved in sin
children of a lesser god
he who loved and sinned
children of a lesser god
he who sinned children of a lesser god
he who sinned children
now they are married
I know a sin

IX

to have hairy skin in jamaica
is a mark of beauty
when I was there I felt beautiful
desired
precious
rare
sort-a-like how I feel when I'm in new york
dark skin
thick lips
dread locks
hairy

jamaica had not forgotten what I looked like
for that I did not humble myself
I indulged

X

the entire time there though
I felt besides myself
out of my element
a bit estranged
oh shit
I felt like a tourist
but not entirely
I still had my accent which
come to think of it
sounded different
compared to the others
I felt like a fucking tourist in
my own country

fifteen years there
six years here
in retrospect even a year here is too long
strip my tongue
my identity

fifteen years there
six years here
in retrospect even a year here is too long

Xl

I want to go home
jamaica
let me crawl into you
protect me from myself
I promise to be humble

gendah bendah

(for sabastian)

gendah bendah/schooling pretendahs
defendahs a di box/trap called man
gendah bendah/yuh nah guh offend har
if yuh tell har seh she don't look like a wo-man

she being me/di queen a androgyny
a put a hole inna yuh whole philosophy
(patriarchy)

mi nuh fit yuh paradigm/mi sorry mi inclined
to follow mi own mind/cuz i'm
an individual
(I-N-D-I-V-I-D-U-A-L)

shave mi head once a week/eye brow mi nuh tweak
mi nuh wear nuh lipstick/nor nuh makeup
(a lie)

den yuh see mi walk by/mi a look kindah fly
cyaan look inna mi eye/don't know if i'm a guy
or a girl
(dyam idiot)

gendah bendah/schooling pretendahs
defendahs a di box/trap called man
gendah bendah/have a feminist agenda
unshackle oomaan oppreshun

years of socialization
shit like
girl wear pink/boy wear blue
boy play sport/girl play house
girl get barbie/boy get fire truck
gendah is a social construct
wi tell har seh she mustn't climb tree/we tell him to dry his eye
we tell har seh fi close har legs/wi tell him seh boys don't cry
we tell har seh fi please har man/wi tell him oomaan deh deh fi please man

gendah bendah/schooling pretendahs
unlearning british colonizashun
gendah bendah/urging di sisters
redefine your feminist position

question di standards a beauty
make-up/hygiene/weight-loss/clothing industry
based pon di sale a we body
dem teach we early seh
if yuh anorexic yuh more beautiful/if yuh physically weak yuh more
feminine-full
if yuh passive an meek yuh more female-full/and if yuh black-work-inna-di-fields-
fi-500 years slave-oomaan strong and assertive
yuh not beautiful/yuh look like a man/bettah still a lesbian

to all my people who be fucking with gendah lines. dissecting race/class/
sexual orientation. what's expected. the status quo. the institutionalized shit.

to all weirdos. people who be responsibly different. she/he he/she transvestite/
transgendered/queer/gay/lesbian/straight/bi/drag king/drag queen

to all people raising their children outside of gender norms. tell them she's a
boy. tell them he's a girl. and let them both play with dolls (not barbie).

to all chi chi man. maama man. sodomite. butch dike. malecon. femme

to all cross-dressers. wimmin who are fathers. men who are mothers.
everybody in between.

to people who don't assume when they meet me that i am boy because i shave
my head.
my clothes are gendah neutral. i stand with shoulders broad. i am not passive
and apologetic.

to people like me gendah bendahs/undoing the social conditioning/
transcending. creating new tradishuns. rediscovering old ones. who bleed di
blood of androgyny. when every foetus born they be she. first. gawdess. always
androgynous. god always androgynous.

ast/vadz

happy to be nappy
(for bell hooks)

black rice grain
nice grain
roll up roll up
spotted with unruly waves
tenshun
can I cut my tongue on strings
pluck dem young ones
from hard tings
taste dry bread
drenched in nappy
run tentacle through
rough ridges
undefined
valleys unreclined
soothe yuh
john-crow draw brakes inna yuh head pickney
how it suh picky picky
bush fire
blaze
barb wire
cut
revolushun start
happy to be nappy

animal farm

(for george w bush & george h w bush)

I say we're living in
we're living in george orwell's
animal farm

manufacture
like a robot inna factory
human life is a monopoly
imperialistic illusion a unity

everybody cried
when diana died
who of you shed tears for sankofa
strange fruit
he was crucified
you oppose me
silence dat n!**#r

consumer unity
is a lie
we gather round a tv station
watch a televised murder
engage wid fascination
same tv station broadcasting

the genocide of another nation (iraq)
talking bout homeland security
911 reminds me of

rwanda
hiroshima
nagasaki
grenada
jamaica
panama
afghanistan
vietnam

don't believe the shit you see on cnn
the us army is not your friend
prisoners of war in guantanamobay
everyday they say
another brother
accidentally dies
ameri—K K K—a television lies

people
popular public opinion prevailing in
past wars
prove di powah of propaganda
di powah of playing on people's fear
(war on terror!)
(war on terror!)
(war on terror?)

manufacture
like a sweatshop workah inna factory
be all you can be
consume tv
drive suv
go on a shopping spree
join the army
think for me
big brother think for me

love equality freedom and revolushun
(for moon)

the words in the computer screen
screamed
blood red
deafening!
bleeding echoes off the walls
the umbilical chord
our unborn child
they shouted
"when the child asks—'where is my father'
tell the child—'your father did not agree with my revolushun'"

my tear-pierced world stopped
shot
by ammunition
deadlier violent than bullets of fresh flesh
clots
shooting their way past a closed cervix
in that first trimester
thought I was/we were having a miscarriage
but not

now
this ancestor spirit—our child
insists on returning
persists on belonging
you
baptized by centuries of male dominance
sanctified in arrogance
crucifying in the name of "dignity" and "tradition"
writes—"tell the child your father did not agree with my revolushun?"

what?!
hmmm! freedom is a very fine ting
how to poeticize this paralysis?

mama di pickney dem mean to mi today
tease mi call mi monkey again today
seh dat mi ugly again today today
mama I do not belong again today

here we have a negro wench
gentlemen and gentlemen
starting at four hundred dollars
strong hands/strong legs/strong spirit
but not stronger than yours
knows how to cook/knows how to clean
knows her place/keeps her place/won't pass her place
in and outside the house
open legs/closed legs/whatever
on demand!

low self-esteem/no self-esteem
who cares!
only four hundred dollars
do I hear five hundred! six hundred! seven hundred! eight hundred?!
eight hundred dollars!
going once/going twice/sold to the highest nigger
for eight hundred dollars!

equality is indeed a very fine ting

we niggers? we monkeys?
we whores/we jezebels/we concubines
we underprivileged/we disenfranchised/we poor
we fresh off di boat/we refugees/we immigrants
we homeless/we single parents/we welfare mamas
we fitting the description/we gangsters/we criminals
we queers/we retards/we rejects
we cubans/we jamaicans/we haitians and afrikans
we black skins white masks but still ghetto and fabulous
have *we* forgotten what it feels like to not *belong*?

we fighting for the right to devowah powah
when di oppressed becomes oppressah
and this bedroom/this kitchen/this bathroom
a model plantation
I play slave you play massah
a maquette concentration camp
I play jew you play hitlah
a make-believe salem massachusettes
I play witch you play witch huntah...

but I will not be burned at the stake
I would rather burn my bra instead
a privilege
after toiling the soil
feeding black and white babies
raped by massah and my man
while being whipped in my back

I would rather
belong to the herstory of outsider outcast warrior womben
who *belonged*
to nothing and no-one
but themselves
remembering
we were never meant to survive

the child is born and asks
"mama where is my father?"
to which I respond...

blood

blood blood blood blood.claat
blood blood blood blood.claat

living inna time/where di blood is marketable
like di rest of my body/everyting is sellable
toxic shock syndrome/proctor gamble
chlorine bleach pad/suck blood mi nuh have

lurking culture vultures/a siddung pon di shelf
legalized pimping a mi cunt and mi blood
wid or widout applicators/wid or widout wings
brands a b c and d/don't give a blood.claat bout me

yuh evah notice/see dem pon tv
cotex tampax always or maxi
dem nuh use red/a blue dem use instead
and i'm wondering from where di shame/around my cunt came from
like a covert operashun/more than half di populashun bleed

we used to have nuff nuff nuff nuff blood ritual
where oomaan come togeddah/and bleed inna di land
but now di blood naw flow/where did the rituals go
manufactured shame/designed to keep me inna chains

I bleed
five nights of bleeding/blood inna mi eye
five nights of bleeding/blood inna mi head
five nights of bleeding/blood inna mi womb
five nights of bleeding/blood inna mi cunt
five nights of bleeding/blood deh pon di ground
and when war come/whose blood run

brixton/railton road/rainbow/blues-dance/telegraph
like rivah blood just a flow/wid blood liberashun have a chance
grenada joburg haiti/slavery
ban mi belly and bleed/ban mi belly and bleed

one century two century three century four/five century overboard
captivity no more for she a cum
blood fi wash yuh hate away/blood fi wash yuh rape
blood fi wash di pain away/blood fi wash di slate clean
blood gwine guh tek yuh/blood gwine guh tek yuh

I bleed
why wi teach young amazons/to hide di fact dat
aunt flow come once a month/and she's a setback?
don't talk about har too loud inna public
be careful not to get CREASHUN pon di toilet
watch out yuh might get some CELEBRASHUN pon di chair
don't stain di sheets wid yuh LIBARASHUN
nor di streets wid yuh REVOLUSHUN
young black bush oomaan/nuh birth a nation

young black bush oomaan walking around
no-one knows har name
she's feeling demonized/dehumanized/disempoweredized
she needs to deprogrammize
close har eyes/and feel inna di darkness
di deepness/di wetness/di redness a blood

I bleed
and when she comes to me once every month
she brings positive vibrashun wid har ciphah
no doc mi nuh waan nuh tylenol/no midol/no advil
no spirit killers to numb dis healing
jus gimme red raspberry tea
and I'll be tranquil
right now she universe is communicating
I am elevating
surrendering myself to she gawdess within

ancient moddah spirit is calling
if I were in di bush/I would be bleeding
in di earth
watering har body wid mi healing
but mi live inna di shitty

no pad no tampon no liner no towel
no oppreshun/sheets well bloody
bleeding pon di bed instead

I bleed becuz I am a warrior
amazon dawtah of Yem-Oya
I bleed becuz di blood of di moon
I bleed becuz di blood of di earth
I bleed becuz di blood of di wind
I bleed becuz di blood of di rain
I bleed becuz di blood of di sun
makes me mawu

ancient afrikan gawdess divine who creates all life
black bush oomaan
ase